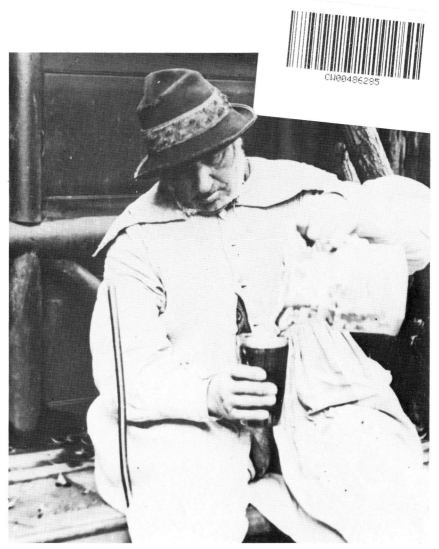

'A glass of ale'.

SMOCKS

Maggie Hall

Shire Publications Ltd

CONTENTS

Printed in Great Britain by CIT Printing Services, Press Buildings, Merlins Bridge, Haverfordwest, Dyfed SA61 1XF.

The cover illustration is from the educational video 'The Agrarian Revolution' produced by Hugh Baddeley Productions on location at Pitstone Green Farm in Buckinghamshire. The photograph is acknowledged to J. D. Hawkins.

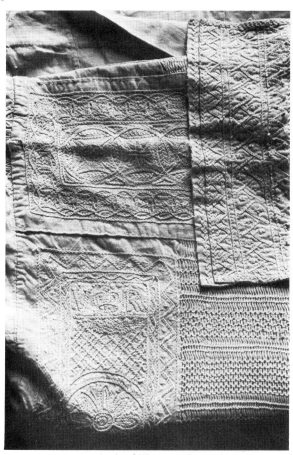

Embroidery on a smock in the Hereford and Worcester County Museum at Hartlebury Castle.

Mr Marsh, the fishmonger.

INTRODUCTION

The smock, smock-frock or slop was a protective outer garment worn mainly by countrymen in England and Wales during the eighteenth, nineteenth and early twentieth centuries. It developed from the full shirt of the mid eighteenth century to a decorated form, in which the fullness over the chest, back and sleeves was controlled by gathering held in place by ornamental stitching. This gathering or smocking was functional as well as decorative as it gave the garment shape and at the same time a certain elasticity allowing freedom of movement.

The complexity of design in the embroidery reached a peak in the middle years of the nineteenth century and the garment gradually declined to the present-day drill overall, which in some parts of England, notably the midlands, is still called a 'cow-gown', whether or not it is worn by an agricultural worker. In parts of rural Herefordshire the word 'slop' is also still used for an overall.

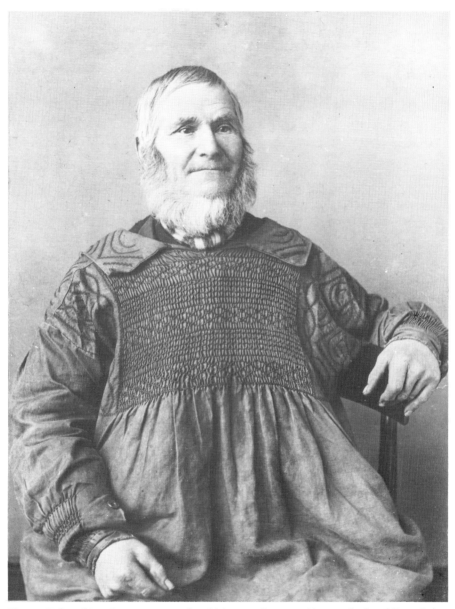

Thomas Pitkin of Swanbourne, an agricultural labourer who gave evidence to the Royal Commission on Old Age Pensions in 1894, when he was sixty-seven. The photograph is thought to have been taken at about this time.

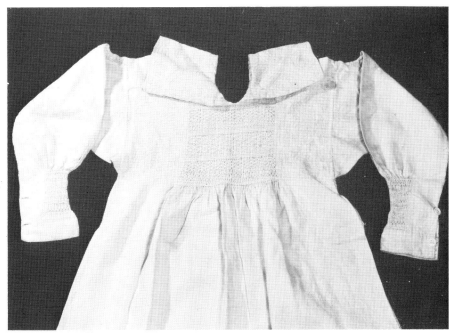

A round-frock, a smock which was the same front and back with a small neck opening. This one is from the Curtis-Hayward Estate, Quedgeley, Gloucester, and is now in the Folk Museum, Gloucester (catalogue number: F24365).

HISTORY

There are few records regarding the early history of the smock-frock and some references can be confusing, as until the eighteenth century a smock was a woman's linen undergarment (later called a shift or chemise) and 'frock' was the name given to the full-skirted coat worn by men until the end of the eighteenth century.

There are, however, a few early references which clearly indicate the smock-frock by relating the shape to a shirt or describing it as a garment to be worn over the clothes for protection.

In the Purefoy Letters of 1741 Henry Purefoy describes the clothes of a 'strange man' from Lincolnshire: 'Hee wears a blueish grey broad cloath coat and wastcoat and a white ffrock over, buttoned at the hands like a shirt'. In a letter of 1746 Henry requests his tailor to 'bring the Coachman a linnen frock to put over his cloaths when hee rubs his horses down'.

The subcommittee of the Foundling Hospital (a children's home in London established in 1739 for the 'maintenance and education of exposed and deserted young children') permitted 'linnen working frocks for outdoor jobs' and in 1755 they allowed 'the Big Boy (who) works in the Garden, Lights the Lamps etc . . . two Frocks, made for him that may wash, to save his Cloaths'. Permission was granted in 1787 for '. . . some strong clothing for Bartholomew Walbroke No. 17,143 . . . who is an Ideot, such as a round Frock, a strong Waistcoat and a pair of Leather Breeches as he is grown a great unruly Boy and Wears his Clothes out very fast'.

The smocks mentioned in these references were simply practical or working garments and there is no evidence of decoration or embroidery. Although the smock continued to be used as a pro-

5

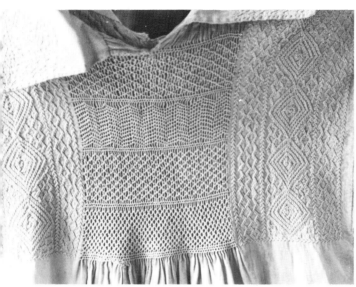

LEFT: *Smock made by Mary Bufton, a smock maker in Hereford until 1835. It was used by her as a sample from which to take orders.*

BELOW LEFT: *An often used design of hearts. This smock originated in Bedfordshire.*

BELOW RIGHT: *Pattern of flowers and leaves used in several areas. This smock is from Warwickshire but the same pattern has been found in Oxfordshire and Salop.*

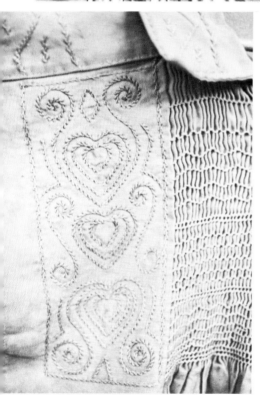

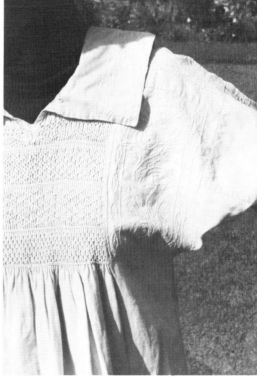

tective garment decoration began to be applied at the beginning of the nineteenth century. A hand-coloured plate dated 1813 in *Picturesque Representations of the Dress and Manners of the English* shows a farmer's boy wearing a smock with gathering across the chest. The text states that the picture 'may be said to represent the usual dress of the farmers' servants in the southern parts of the country. The frock which he wears over his other clothes, is made of coarse linen, much in the same form as a shirt, except that the front is close, and usually stitched or plaited in a fanciful manner as are also the shoulders and back part of the neck'. The paintings of James Ward (1769-1859) often included smocks but again generally show gathering but no embroidery.

The fully embroidered smock with decorative stitching on either side of the gathering front and back, as well as on the shoulders, collar and cuffs, does not appear until about 1830. There are several examples of early embroidered smocks, one being in Hereford City Museum. This smock was made by Mary Bufton, a smock maker in Hereford who is known to have worked until 1835, when she married. In the *Workwoman's Guide*, which was published in 1838, there are drawings of a wagoner's smock and instructions for

making it: 'made of strong linen, similar to that used for sheeting, and the biassing upon it is worked with the strongest glazed thread or cotton that can be procured. This work must be firmly and regularly done as the price of these frocks depends on the quantity and quality of the work in them. The shoulders and wrists as well as the back are biassed with strong glazed thread in various patterns and stitched as in Figure 16. The plain part between the biassing and the armhole is worked in chain stitch, as also the collar in various patterns. These frocks are to be met with at clothing warehouses, and cost from 9s to 18s each, the price depending on the quantity and quality of the work put in'. (Figure 16 shows the upper part of a smock and indicates the parts to be embroidered.)

The smock reached a peak of popularity in the middle years of the nineteenth century and the embroidery at this time was often very complex and beautiful. It was a garment to be worn with pride and *The Times* of 13th June 1851 describes an outing to the Great Exhibition at the Crystal Palace: 'A remarkable feature of yesterday's experience in the interior of the Exhibition was the appearance there, at an early hour, of nearly 800 agricultural labourers and countryfolk from the neigh-

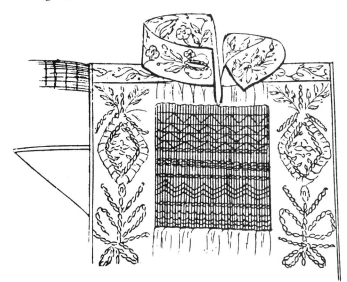

Diagram of a 'wagoner's frock' from 'The Workwoman's Guide' (1838), with (above) detail of a cuff.

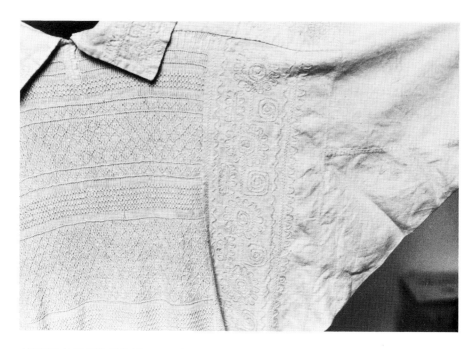

ABOVE AND BELOW: *Three smocks, all from Worcestershire, with the same pattern. One was worn by at least three generations of the family of Mrs Mann when attending divine service at Chaddesley Corbett church on Sundays, the other two by Ambrose Foley, a farmer, and L. Penoyre, a butcher.*

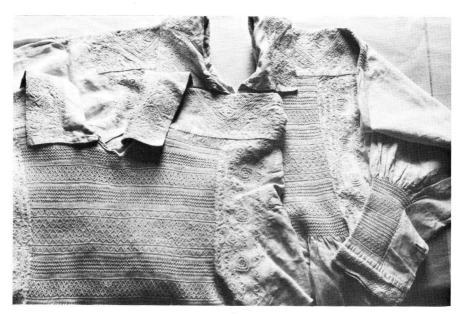

bourhood of Godstone in Surrey, headed by the clergymen of the parishes to which they respectively belonged. . . the men wore their smartest smock frocks and the women their best Sunday dresses and more perfect specimens of rustic attire, rustic faces and rustic manners could hardly be produced from any part of England'.

The decline of the smock may be explained partly by the increased mechanisation of agriculture, when a long full garment would have been both inconvenient and dangerous, and by the increased manufacture of clothing. There is a third reason, a social one, which is mentioned in an article written in 1937 for the *Sussex County Magazine*. It tells of a countryman whose daughter, in service in London about 1887, deplored her father's old-fashioned way of dress and substituted a new coat for his best Sunday smock. The old man, however, was so appalled at the idea that he preferred to walk through the village in shirt sleeves rather than wear the new coat. Another story recorded in the same article tells of a similar countryman who visited his daughter in London. He wore his best smock-frock for the occasion and the little boy of the house was heard to ask: 'Liza, why does your dadda come to see you in his nightgown?' These two stories show how the smock-frock, although beloved by its owner, was often socially unacceptable to the young people towards the end of the nineteenth century as it branded its wearer as a countryman, not necessarily a compliment in the fashionable city.

Although the smock was already a curiosity by the end of the nineteenth century in some parts of the country, elsewhere, notably in Herefordshire and Sussex, it was worn during the early part of the twentieth century.

A smock of unusual design demonstrating how the maker often used her own ingenuity rather than keeping to traditional patterns.

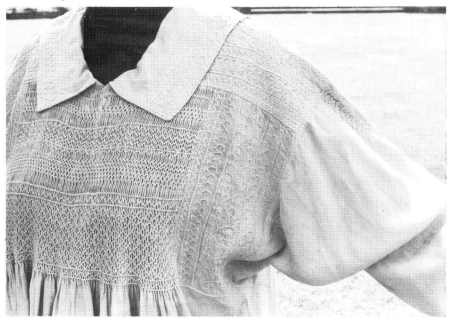

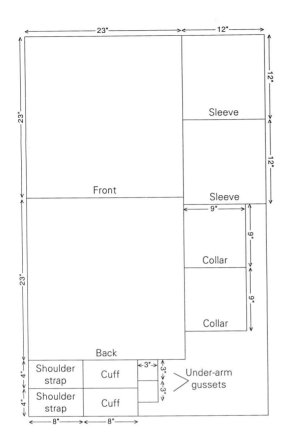

Diagrams for making a smock for a child about two years old. On the left is the plan for cutting out, below is the gathering diagram.

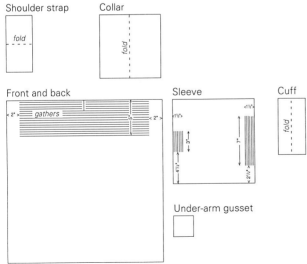

10

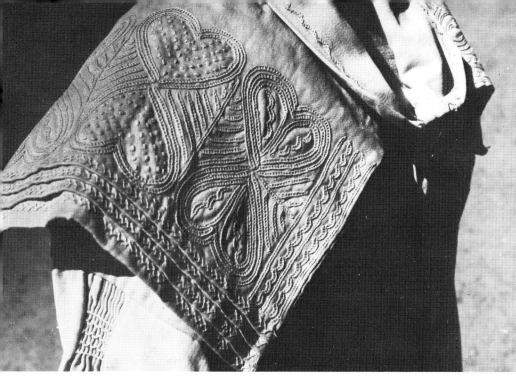

A Herefordshire smock showing a large 'shoulder collar', a feature very common in smocks from Herefordshire and Wales.

TYPES OF SMOCK, COLOURS AND DECORATION

The smock was cut very economically. All of the pieces were either squares or rectangles (except sometimes the collar which was rounded), the shape of the garment being given by the smocking.

There were two main forms: the round-frock, which was the same back and front with a small neck opening of about three inches, and the coat-type smock, which opened further down the front, sometimes to the hem. The coat-type very often had a yoke at the back and a rounded collar. There was great variety in the shape and size of the collar and also in the pockets, which were anything from a simple slit in the side seam with a patch underneath to those with embroidered flaps and buttons.

The two main forms may be subdivided into other groups according to the amount of gathering and embroidery. This varies from about 2 square inches (13 square centimetres) of gathering on either side of the neck opening, with the embroidery reduced to perhaps a single line of feather stitch on the collar and shoulders, to the heavily embroidered round-frock with gathering front and back extending to 13 inches (33 centimetres) or more. The latter type usually had decorative motifs worked on the 'box' (the panel between the gathering and the side seam), the collar, shoulders and cuffs.

It was usual for a man to have two smocks, one for work and one for special occasions. Working smocks were generally made of coarse twill or drabbet and often beige or fawn, although in some parts of England other colours predominated. Blue smocks were common particularly in the midlands, where they were manufactured at Newark.

Messrs Brown and Crosskey of Lewes, who made smocks for a century, made

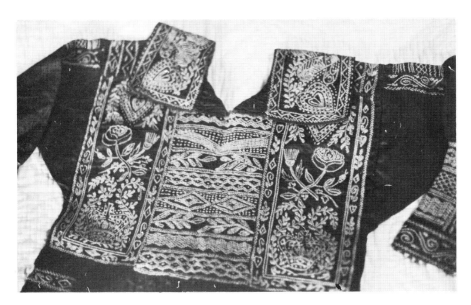

ABOVE: *Child's smock showing 'patriotic' symbols.*

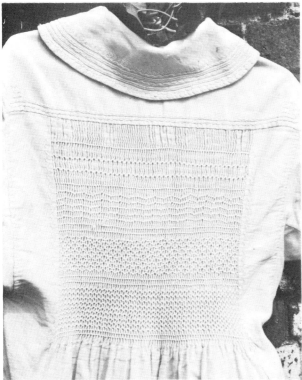

LEFT: *A smock from Ledbury, Herefordshire, showing great width and depth in the smocked panel but very little embroidery on either side.*

12

black smocks as well as supplying 'dark grey for shepherds, drab for cowmen and ploughmen and royal blue for butchers'. Brown smocks were worn in Surrey, Sussex, Essex, Hertfordshire and Suffolk and green ones in Essex, Hertfordshire, Bedfordshire, Cambridgeshire and Northamptonshire, although reports of green smocks can be confusing as what is called green in one area may be called drab in another.

In the article 'The Sussex Smock or Round-Frock' (the *Sussex County Magazine*, 1937) it is stated that 'Messrs Horace and Carlos Coleman always wore green smocks at their shooting parties. The garment was usually made of coarse calico and was impregnated with linseed oil which rendered it weatherproof.' There are two smocks, one in the Birmingham City Museum and one in the Victoria and Albert Museum, which have a distinctly tacky feeling, suggesting that they may have been treated with oil in this way.

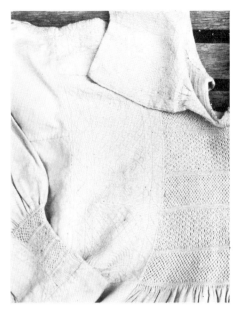

Smocks for special occasions were made of finer linen and, apart from a few rare examples, were white. They were worn on Sundays for church and on special days such as jubilees and other times of national celebration as well as at weddings and funerals.

The thread used was linen, often waxed, and generally the same colour as the fabric, for example white on white, blue on blue or beige on beige. In a few areas a thread of contrasting colour was used.

The stitches were simple although the designs worked were often intricate. They were mainly the various forms of feather stitch, chain stitch and French knots.

DECORATION AND EMBROIDERY

It has been suggested that the embroidery on smocks can be related to particular counties and that the motifs used were symbolic of the trade or occupation of the wearer. Although this can be applied to certain smocks the evidence is that neither suggestion is entirely valid.

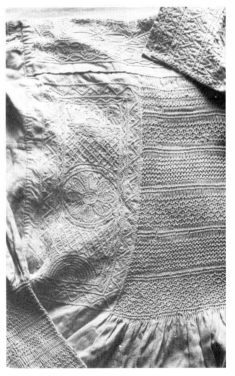

Two smocks, one from Oxfordshire and one from Worcestershire, with identical patterns on front and back. 'VR' and a crown are worked at the top of the box and they were probably made to celebrate the accession of Queen Victoria in 1837.

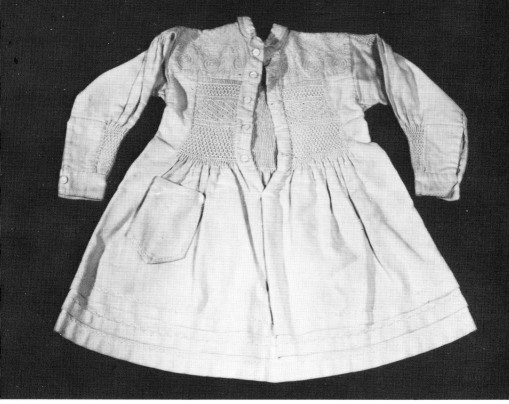

Coat-type smock–one which opened down the front and often had a yoke at the back. This is a child's smock said to be an exact replica of a contemporary (c. 1870) carrier's smock. Originally from Shrewsbury, now in the Folk Museum, Gloucester (catalogue number: F689).

An exhibition of smocks was arranged by Miss Anne Buck at Platt Hall, Manchester, in 1962 and for this Miss Buck collected a great deal of information from different parts of Britain. Fifty-four smocks were fully examined and a further sixty-seven studied from photographs and descriptions. This study produced no definite evidence of a connection between embroidery and occupation.

There are some smocks on which the motifs can be interpreted as representing the owner's occupation. One example is a shepherd's smock in the Victoria and Albert Museum with what are thought to be crooks and hurdles embroidered on it. Another is a child's smock from Shrewsbury (now in the Folk Museum at Gloucester), said to be an exact replica of a contemporary carrier's smock, with 'whips' and 'cartwheels' as motifs. Both of these smocks were made for special occasions, the first for a bridegroom by his

bride and the second for the children of one family–it was handed on as babies arrived. When such a garment was made by a close relative of the wearer, as was often the case, it seems quite reasonable that she should incorporate some indication of the man's skill in her design. An old shepherd from Hertfordshire once recalled that his smocks were bought plain and decorated by his womenfolk; he had crossed crooks worked on the shoulders.

Flowers and leaves were commonly used motifs and as a great number of the wearers of smocks were employed to some extent in agriculture or horticulture many of them would have had these appropriate designs.

In spite of such examples it seems that smocks with designs directly related to occupation are the exception rather than the rule.

Where one woman made smocks for everyone in her village she often had a

favourite design and so all her smocks would be alike. It is probable that her design would be appropriate for at least one man in the village. There are three smocks, one now in Birmingham City Museum and two at Hartlebury Castle, which have an identical design of flowers and leaves. All three came from a fairly small area in Worcestershire and the work is distinctive enough to have been made by the same person. The occupation of the owner of one is unknown but the other two belonged to a farmer and a butcher, very different occupations, and certainly the floral design cannot be related to the latter.

Mrs Margaret Jones in an article for *Country Life* in 1957 suggests that, if the thesis relating design to occupation is correct, a smock in Hereford City Museum showing hearts, wheels and leaves must have been worn by a very versatile worker indeed.

Some designs were more popular in certain areas, for example the 'teardrop' or 'paisley' pattern, which is often found in Herefordshire and Wales, as is that of interlaced hearts.

Although areas cannot be definitely connected with patterns it is possible to group some smocks according to shape or form. This has been shown both by the work of Miss Anne Buck and by that of Dr Dance, who arranged an exhibition of Surrey smocks at Guildford in 1961. The clearest of the groupings is the smock with

BELOW LEFT: *A patriotic smock with Britannia in the centre circle and a crown above.*

BELOW RIGHT: *A pattern which was much used towards the end of the nineteenth century in many parts of Britain. The complex work on smocks of earlier years has disappeared but the basic shapes of the motifs remain the same This one is from the Folk Museum, Gloucester (catalogue number: F696).*

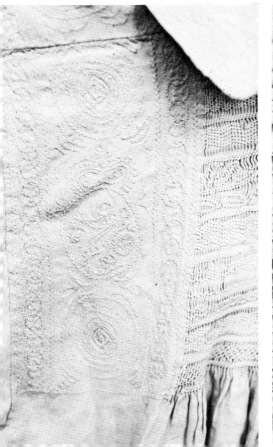
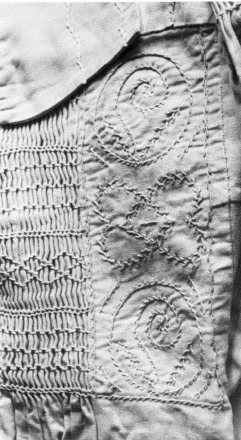

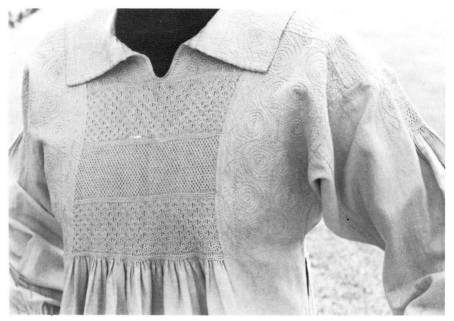

ABOVE: *A smock made for Mr Hyatt of Great Welford to celebrate his third wedding anniversary. The material was spun and woven by his sister.*

OPPOSITE: *John Turvey of Swanbourne, 1910. The smock is being worn over his best suit, showing that to some it was still a garment to be worn with pride even as late as 1910.*

a very small amount of gathering on either side of the neck opening and very limited embroidery, the garment closely resembling a shirt. This type was typical of Surrey and Sussex.

Another regional variation was the large 'shoulder collar', which was a rectangular flap extending over the shoulder. This was very common in Herefordshire and in Wales although there are examples from other areas.

A smock which belonged to a wagoner from the Bridgnorth-Shifnal area bears a marked resemblance to Herefordshire smocks in both cut and decoration. It is a coat-type smock with a large shoulder collar and a design of hearts. It also has an unusual feature which appears on a child's smock from Hereford–a small diagonal sprig motif worked between each buttonhole. Although it is thought that the Bridgnorth smock was worked by the man's wife it is interesting that the char-

acteristics of shape and design all appear in the work of a smock maker in the Ludlow area who was working at about the same time.

Some smocks have such unusual designs as to suggest that often the pattern depended very much on the ingenuity and skill of the maker.

Extremely complex designs were sometimes worked to celebrate special events such as jubilees or the Great Exhibition at the Crystal Palace in 1851. A smock in Birmingham City Museum, possibly made at the time of the Great Exhibition, is worked in extremely fine feather stitch and has the words 'God speed the plough' and 'Success to trade' embroidered on the collar. There are also sheaves of corn, ploughs, harrows, rakes, pitchforks, hearts and flowers all worked in the finest detail.

There are two very similar smocks, one in the Oxfordshire County Museum and one at Hartlebury Castle, which are

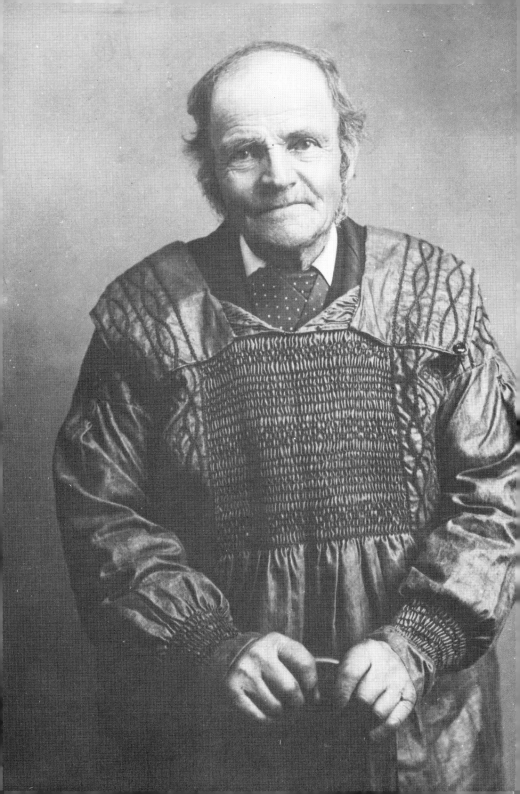

thought to have been made to celebrate the accession of Queen Victoria in 1837. 'VR' and a crown are incorporated into this design. The rose, thistle, shamrock, Prince of Wales feathers and crown were all motifs used on this type of 'patriotic' smock and a superb example is a child's smock, originally from Buckinghamshire, on which all of these appear. It is blue with white embroidery and is a beautifully executed piece of work showing little or no sign of wear. It represents many hours of work and has obviously been carefully kept.

A smock in the Victoria and Albert Museum has Britannia, as she appeared on the back of an old penny, embroidered on the box, but the work is cruder than on other patriotic smocks–perhaps the maker was a little over-ambitious.

Embroidery on later smocks, those made towards the end of the nineteenth century and after, was generally simpler, often reduced to two or three lines of feather stitch, although some retained a vestige of the intricate patterns worked in the mid nineteenth century. One particularly good example is the pattern of interlaced hearts, leaves and coils which appears in many later smocks from several different areas.

It is possible that some early smocks were typical of an area, even of one particular village, but as transport improved and people began to travel more freely ideas would also have travelled and patterns would have been copied.

Collar of a smock probably worked at the time of the Great Exhibition in 1851. The embroidery is exceptionally fine and represents many hours of work.

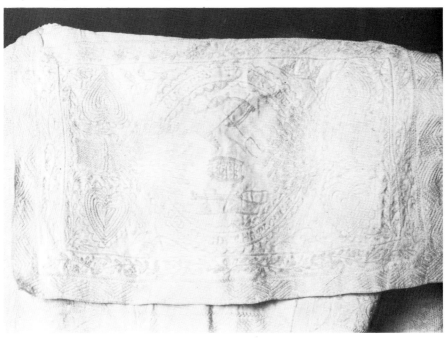

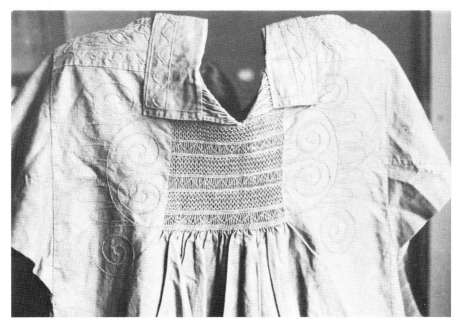

A Newark frock. The patterns were printed on with metal blocks and then the fabric was sent to outworkers to be embroidered.

MAKERS

Working smocks were very often manufactured but smocks made for special occasions were generally made by a member of the wearer's family. Some of these 'special' smocks were very beautiful and obviously entailed many hours of work. They were worn comparatively rarely and often handed on through the family. A smock has been known to have been worn by five generations of one family.

The manufacture of smocks took place in several parts of the country on a scale ranging from one woman in a village making all the smocks for that village to industries like the Newark smock-frock industry. There were ten manufacturers of smocks working in Newark between 1826 and 1872, when the industry was at its height. The linen was woven in the town and dyed the distinctive blue of Newark. A pattern was printed on to the fabric using locally made metal blocks and the embroidery was then done by outworkers.

There were many individual expert smock makers, for example Mary Bufton of St Peters Street, Hereford, who worked until 1835, the year in which she was married. Hereford City Museum has a smock which she used as a sample from which to take orders.

At Headington Quarry in Oxfordshire a Mrs Kimber was an expert at smocking. She could make two smocks in a week and to amuse her small boy would allow him to thread and wax her needles. A similar story was told to Judith Masefield by an eighty-eight-year-old Berkshire labourer ('A Gathering of Smocks', *The Countryman*, spring 1968): 'I did use to have to walk from Wheatley to the factory at Oxford with a bundle of those heavy smocks as our Mam worked in crinkle-crankle stitch. Blue, black and white

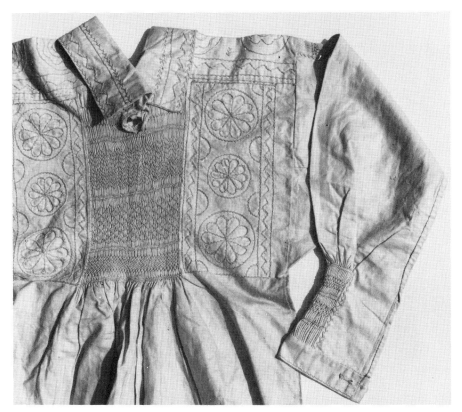

This smock is unworn and the stencil or ink marks can be seen under the embroidery on front and back. It has a printed paper label stitched to it which reads 'Men's dbl wrkd 20 nls' and is a smock which would have been sold ready-made in a shop.

milking smocks as I'd waxed the thread for and ruled the lines on in chalk. Mam only fetched in ninepence a smock.'

A woman from a village in Sussex told Anne Buck that the carrier's cart used to bring the material on Monday mornings, her grandmother would pencil out the designs for smock and embroidery on the kitchen table, hand it out to the other village women, and the carrier would collect the work on Friday and presumably take it to the factory to be made up by machine.

Smocks were often manufactured in areas where flax was grown, a good example of this being at Knighton in Powys. The flax was grown and spun by the Price family at Tyn-y-Waen and then made up into smocks, which were taken to Mr Jones, the tailor in Knighton, who sold them at 5s 6d each with a pair of replacement collars at one shilling.

A smock industry existed in Abingdon, Oxfordshire. Harris and Tomkins of Abingdon exhibited two smocks at the Great Exhibition in 1851. They were designed by T. Watson and worked by Hannah and Esther Stimpson, who were cottagers of Radley. Esther's smock was awarded a medal.

RIGHT: *Detail of shoulder of a Newark frock.*

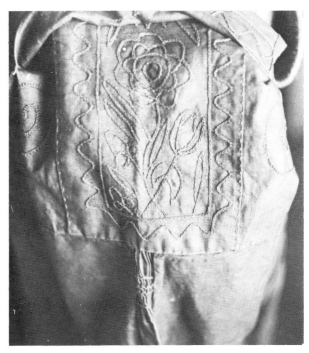

BELOW: *Smock made by a village woman at Magdalen Laver in Essex in 1915. It cost 14 shillings.*

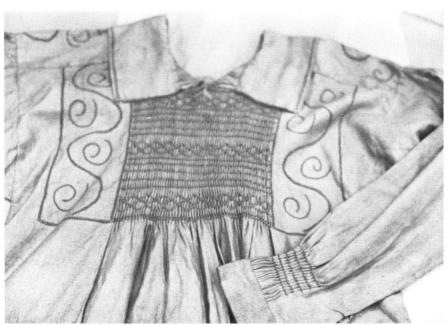

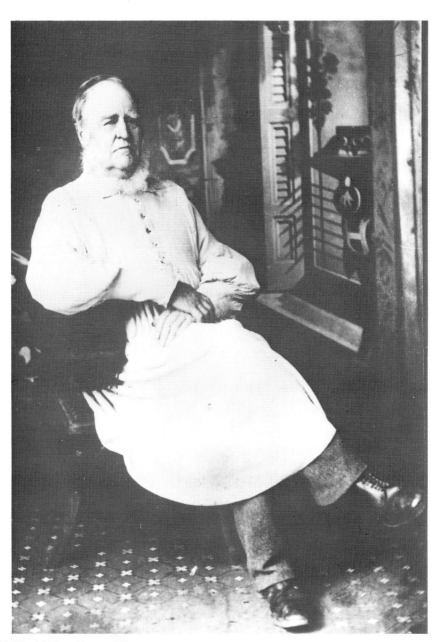

Mr Wooldridge of Lye, c. 1880.

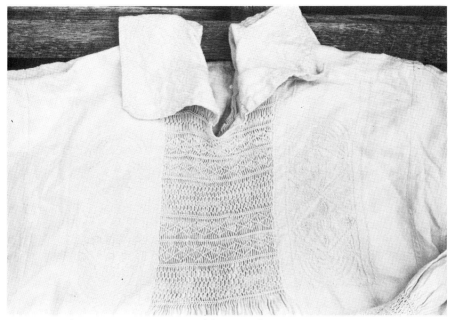

One of a set of six pallbearers' smocks from Piddington, Oxfordshire.

WEARERS

The wearing of smocks is usually associated with those employed as farm labourers but they were worn by countrymen following many different professions, for example ploughmen, wagoners, gardeners, woodmen and gamekeepers. Shepherds often wore them as they provided an excellent protection against cold and rain.

Tradesmen such as butchers, fishmongers and tailors were also known to have worn smocks and Pyne's drawings of the early nineteenth century show cider makers and brewery workers wearing them.

Smocks worn by stonemasons had very little gathering on them as the stone dust would collect in the gathers and, particularly during wet weather, make the smock too heavy. One stonemason from Oxfordshire used to have a pocket in his smock for his ruler and pencil 'in case he needed to measure anything'.

One pig farmer always wore a smock when catching pigs for market as it stopped them running between his legs.

A smock was made by a parishioner for the vicar of Monkland in Herefordshire to wear at harvest time, but it shows little evidence of wear.

White smocks were worn at funerals as a sign of mourning and a village would sometimes have a set of smocks for the pallbearers. The village of Piddington in Oxfordshire had a set of six identical ones and they were kept in the church so that on the occasion of a funeral the men could come straight from the fields and exchange them for their working smocks.

A landowner, Squire Vaughan of Llandefalle, had a smock made for him. This was unusual as the smock was not considered to be a garment worn by the upper classes, but it is thought that Squire Vaughan was a man who wished to be very much a part of his community.

Judges at livestock shows sometimes wore smocks and they were even given as prizes. The Buckinghamshire County Museum has a smock which was won in a ploughing match. Naomi Tarrant, in the booklet *Smocks in the Buckinghamshire* *County Museum,* states that at the coronation festivities in Aylesbury in 1838 smocks were given as prizes for a race for 'men between fifty and sixty', for boys 'to eat rolls and treacle', and for 'jumping in sacks'.

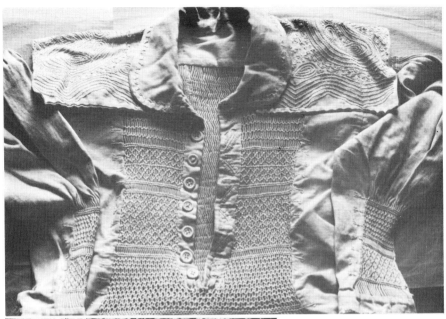

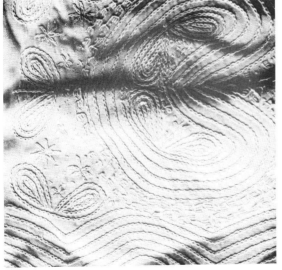

ABOVE: *Smock worn by three generations of the Bow family of Bewdley, who were woodmen.*

LEFT: *A detail of the collar.*

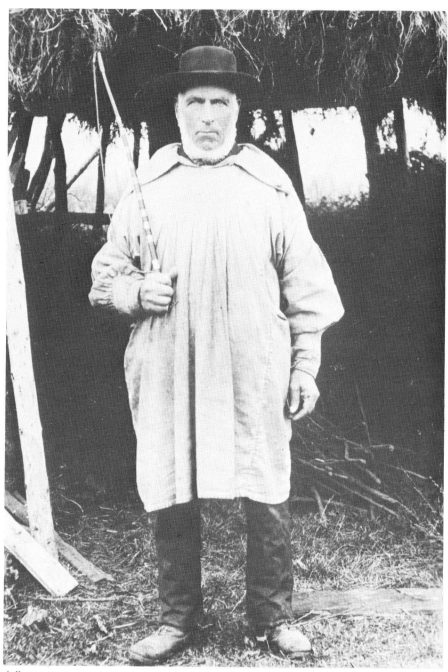

A Dorset carter.

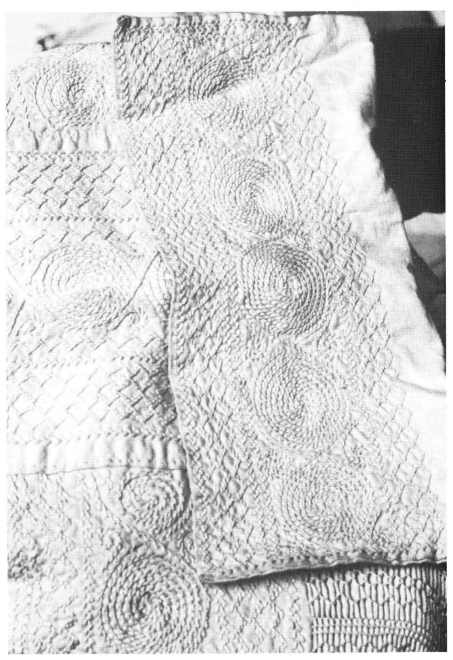

Smock worn by Thomas Taylor, a gardener, who lived at Rea Street, Birmingham. It may have been made for his son's wedding in 1864.

RIGHT: *Smock which belonged to a cowman at Whitnash in Warwickshire who was gored to death by a bull at the age of sixty-five in 1892.*

BELOW: *Detail of shoulder.*

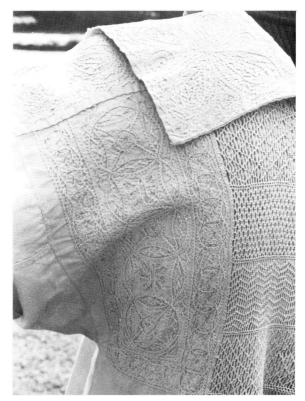

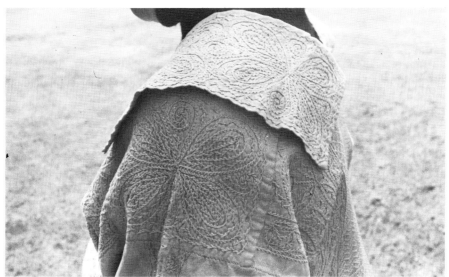

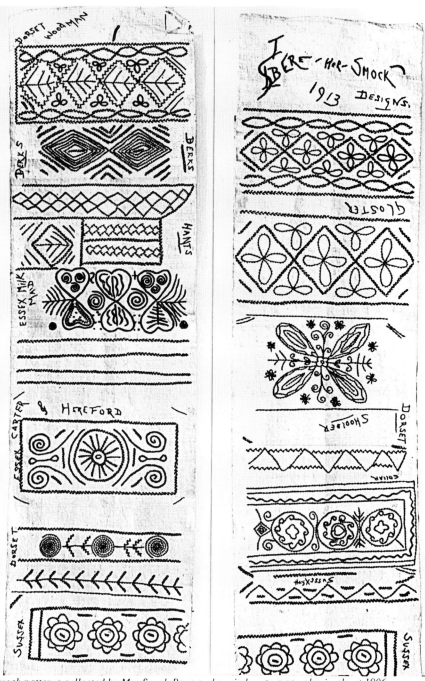

Smock patterns collected by Mrs Sarah Bere and copied on to a sampler in about 1906.

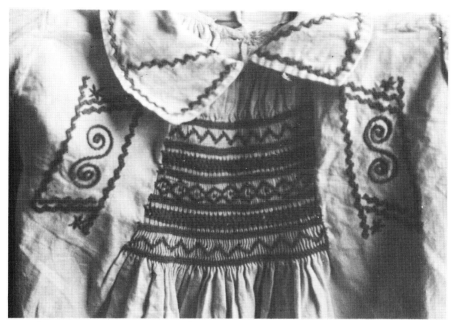

'Ploughboy's blouse', a product of the craft revival in the 1870s. It belonged to Master Andrews of East Brent.

REVIVALS

There have been several revivals of interest in smocks and smocking, the first being in the 1870s when the technique of smocking was taken up by the world of fashion to decorate women's and children's clothes. Although men were still wearing smocks at this time in many parts of England and Wales smocking never became part of the fashionable dress for men.

Much of the credit for the early revival of smocking was attributed to Mrs Oscar Wilde, who was an active member of the Rational Dress Society. One of the aims of the society was that corsets should be abandoned and clothes be loose and non-constrictive.

Liberty, the London shop, also played a great part in the fashionable revival of smocking. In 1884 a costume department was opened where dresses were designed and made up in Liberty fabrics. The children's dresses were strongly influenced by the illustrations by Kate Greenaway for her books. Kate Greenaway drew many children wearing either smocks of traditional shape or smocked dresses. In 1887 Liberty issued a catalogue of 'Art Fabrics and Personal Specialities' which included drawings of 'Liberty Art Costumes'. One was 'a peasant dress in thin Umritza cashmere, embroidered and smocked', and there were also four pages of 'Artistic Dress for Children', all after the style of Kate Greenaway with smocking at the waist, or neck and cuffs. In 1889 the fashion spread to France when Liberty opened a branch in Paris with a children's salon specialising in smocking and Kate Greenaway dresses.

In the early years of this revival the fashionable ladies would send their fabrics to the country to be smocked by cottagers who were experts at the craft but gradually

these ladies learnt the work themselves. An article by E. T. Masters in the *Woman's World* of 1888 gave instructions for smocking and Weldons began publishing patterns and instructions for making up smocked garments in 1887. Whereas the expert smock makers in the country would gather up the fabric by eye, using no aids to keep the gathers straight and even, the fashion-conscious ladies who did not have this skill used either transfers or specially perforated card to mark a guideline of dots on to the material. With smocking made easier in this way it was used on all kinds of garment, for example bathing dresses, dressing gowns, tea gowns, tennis dresses, and 'Garibaldi' blouses. Some children's clothes were made in the style of the smock-frock however, a garment which was still quite ordinary to a country child but a novelty for one living in town. The third series of Weldons' *Practical Smocking* gives instructions for a 'plough-boy's blouse' and states: 'This little smocked pinafore or blouse is made exactly after the style of the smocks worn by country-people, it is exceptionally pretty for boys in petticoats as well as those wearing suits, as it forms a thorough protection and at the same time is very pretty.'

Other revivals have taken place in which the garments were closely based on the traditional smock-frock. One of the most important of these was initiated by Mrs Sarah Bere, just before the First World War. Mrs Bere was the wife of the vicar of Bere Regis in Dorset and set up her village industry in about 1906 in two unused rooms in the vicarage. Her interest in smocks was aroused by her uncle, who was then curator of the County Museum in Dorchester. Mrs Bere collected smocks from all parts of England and Wales and copied the designs on to a sampler. The women of the village first attended classes to learn the craft and then, when proficient, made exact copies of old smocks for sale or exhibition. One order was received from Queen Alexandra. 'The Bere Regis Arts and Crafts Association', as the enterprise was called, ended in 1916 when Mrs Bere took up war work but some of the villagers continued to make smocks for several years. Mrs Bere's son, Rennie Bere, writes: 'As a small boy I was dressed as a woodman or a shepherd and so escaped the sailor suits of my contemporaries. I was probably a great deal more comfortable.'

Today there is more interest than ever in smocks and smocking, partly because people are taking up traditional crafts and partly because they realise that the smock is a beautiful and practical garment.

'Silk dresses will be much worn this season, & the fabric to make silk popular has at last been found in Bengaline. the richest looking & best draping silk fabric that has been yet produced. Velvet will be much used & also brocades for suitable costumes. some of the newest patterns are detached flowers & figures of strong contrasting color & the ground-color of the silk. Pongee silks will be as much in demand as ever and this is a very pretty little child's frock made in that fabric in all colours /

Extract from a costume catalogue of 1890.

30

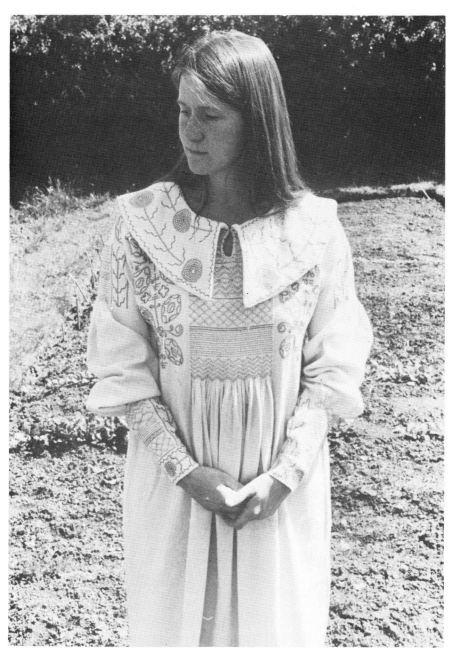

A modern smock made by the author.

FURTHER READING

Buck, Anne. 'The Countryman's Smock. *Folk Life Volume I*. The Folk Life Society, 1963.
Cave, Oenone. *English Folk Embroidery*. Mills and Boon, 1965.
Oakes, Alma, and Hamilton Hill, Margaret. *Rural Costume, Its Origin and Development in Western Europe and the British Isles*. Batsford, 1970.

PLACES TO VISIT

Smocks can be seen in many county and rural life museums throughout England and Wales and also in some country houses open to the public. However, smocks may not always be on display and to avoid disappointment visitors are advised to telephone before making a visit.

Birmingham Museum and Art Gallery, Chamberlain Square, Birmingham B3 3DH. Telephone: 021-235 2834.

Buckinghamshire County Museum, Church Street, Aylesbury, Buckinghamshire HP20 2QP. Telephone: 0296 88849.

Cambridge and County Folk Museum, 2/3 Castle Street, Cambridge CB3 0AQ. Telephone: 0223 355159.

Gloucester Folk Museum, 99-103 Westgate Street, Gloucester GL1 2PG. Telephone: 0452 526467.

Guildford Museum, Castle Arch, Guildford, Surrey GU1 3SX. Telephone: 0483 444750.

Hereford and Worcester County Museum, Hartlebury Castle, Hartlebury, near Kidderminster, Worcestershire DY11 7XZ. Telephone: 0299 250416.

Hereford City Museum, Broad Street, Hereford HR4 9AU. Telephone: 0432 268121.

Luton Museum and Art Gallery, Wardown Park, Luton, Bedfordshire LU2 7HA. Telephone: 0582 36941.

Oxfordshire County Museum, Fletcher's House, Woodstock, Oxfordshire OX7 1SN. Telephone: 0993 811456.

Somerset Rural Life Museum, Chilkwell Street, Glastonbury, Somerset BA6 8DB. Telephone: 0458 831197.

Victoria and Albert Museum, Cromwell Road, South Kensington, London SW7 2RL. Telephone: 071-938 8500.

Warwickshire Museum, Market Place, Warwick CV34 4SA. Telephone: 0926 412500.

Woodspring Museum, Burlington Street, Weston-super-Mare, Avon BS23 1PR. Telephone: 0934 621028.

ACKNOWLEDGEMENTS
The author wishes to thank the following people for their help and information: West Midlands Arts, Anne Buck, Rennie Bere, Oenone Cave, Christine Bulmer, the staff of museums in various parts of England and Wales.
The photographs are reproduced by kind permission of the following: Peggy Arkinstall, page 12 (upper); Rennie M. Bere, pages 25, 28; Mrs Groves, page 12 (lower); Birmingham Museum and Art Gallery, pages 8 (upper), 18, 21 (lower), 26; Buckinghamshire County Museum, Aylesbury, pages 4, 17, 20; Gloucester Folk Museum, pages 5, 14, 15 (right); Hereford and Worcester County Museum, Hartlebury Castle, pages 2, 8 (lower), 13 (lower), 22, 24 (both); Hereford City Museum, pages 1, 6 (upper), 11; Oxfordshire Museum Services, Woodstock, pages 13 (upper), 23; Victoria and Albert Museum, pages 6 (lower left), 15 (left); Warwickshire Museum, pages 6 (lower right), 9, 16, 27 (both); Woodspring Museum, Weston-super-Mare, pages 3, 19, 21 (upper), 29. The photograph on page 1 was taken by Alfred Watkins and other photographs, except historical ones, were taken by Andy Hall.